Lunch Hour

Adam Blue

Book Copyright © 2013 Adam Blue
Artworks © 2007 Adam Blue
adamablue.com

All rights reserved. No part of this book may be reproduced in any form without the written permission of the publisher, except in the case of brief quotations embodied in critical articles or reviews.

Disclaimer: This book and the images contained herein are works of art. The use of Dartmouth half-sheet stationary does not imply or constitute an endorsement from, affiliation with, or sponsorship by Dartmouth College.

Stone House Press
247 Burr Road
Cornish, NH 03745

First Printing, 2013

ISBN: 1492372226
ISBN-13: 978-1492372226

This book is dedicated to my past, present,
and future co-workers and colleagues.

Onward!

Introduction

Work-life balance—the very notion feels rooted in the pursuit of happiness, inextricably bound to the American Dream. Yet the more I consider it, the less it applies to me or to anyone I know. In fact, the concept itself may be a sleight-of-hand trick, because, unlike most terms, which feel natural describing or affirming a presence, work-life balance was born of a lack, created from our need to express that which we've lost over that which we have.

As with any late-industrial economy, we were promised that advances in technology and globalization would deliver better work experiences and greater leisure time. And while many undeniable benefits have been realized from this agenda, the gains have also come with losses. Manufacturing jobs became safer, then moved offshore. Improvements in our cell phones, computers, and the Internet gave us the "information superhighway." Shortly thereafter, we got our digital tethers, as we're all held accountable to bosses, clients, family, and friends—our respective social "need-works"—twenty-four hours a day. I wonder: how much further can we be pushed by our own ambitions? And to what end?

The signs revealing our cultural dis-ease with this dynamic are everywhere. Corporations market their distinctive "business cultures" to new recruits, anticipating candidates' laments before their first day starts. A cottage industry has developed around work-life balance consciousness, with business school gurus and life coaches publishing well-spun screeds for our consumption. Recent innovations in the field include: *Work-Life Balance Isn't the Point!*, *'Work-Life Balance' Should Be 'Work-Life Integration'*, and *Jive Survey Hints the Work/Life Balance Concept Is Dead*. For all our visionaries minting pages of articles on the topic, the tone is curiously homogenous, as each piece persuades us to embrace the changes we're seemingly destined to tolerate.

The solutions offered feel misguided, since, somewhere at their core, they presume we all work in our chosen fields, a privilege that only the luckiest among us will know. For most of my life, this assumption has not been consistent with my experience—that of a worker, now with a family, who clocks full-time-plus hours each week, who has frequently held two or more jobs at the same time and often in different fields, who would never turn down a chance to freelance on the side, who volunteers for good causes, and who is also an artist—committed to his own creative practice at every moment. I'm not complaining: I'm accustomed to how things work. But speaking as an artist, the public conversations we're having about how to remedy our work-life-balance issues are ones I can only witness from the sideline, nodding politely with shoulders shrugged. Until our experts change their focus to an art-family-life-work balance model, I'll continue living beyond the boundaries of their wisest words. *Lunch Hour* is my first visual meditation on the topic.

I made *Lunch Hour* while working full-time, and with great appreciation, as an administrative assistant at Dartmouth College. The department that employed me is fantastic, staffed with great people working hard to better the institution and the world. My position was a straight-ahead desk job, with the expectation to be at work Monday through Friday, from 8:30-5:30, with the standard unspoken subtext that you can always do more, and most do. Knowing that stable income and access to health insurance are priorities of parenthood, I was and am thankful to have had the opportunity to contribute to the college's mission—though making art was never far from my mind.

My cubicle was spacious as cubicles go, outfitted with a desk, a computer, some drawers, and a filing cabinet—sections of which hadn't been cleaned out by previous employees. Since I work efficiently, I had time to explore some of the legacy materials orphaned in the desk's back corners. I found maps of distant cities, train schedules long obsolete, pamphlets advertising hotels, and articles selectively torn from dated publications. There was a richness of office supplies—from the most essential to ones with uses I couldn't determine. There was someone's lost coffee cup, perhaps a gift from a loved one to bring cheer throughout the week.

Including the commute, I would leave the house each morning by 7:30 and get home at 6:30. Family-time was the priority for the evenings, with the pre-dawn hours dedicated to keeping up with life—doing laundry, making lunches, and generating the list of chores that would require attention over the weekend. Leisure seemed a distant dream, and making art was fading fast.

Lunch Hour took form when I realized that the only chance I had to make something was during lunch—the mandatory, unpaid hour in the middle of the day when I usually sat at my desk, eating leftovers and plugging away at work-related projects, simply because an hour isn't long enough to go anywhere, find parking, do anything, and still get back in time.

I distinctly remember a conversation I had with one of my art mentors. She challenged me about my habit of making diverse types and bodies of work. I had answered that inspiration came from the process of exploring ideas and materials, reflecting on how it felt to do what you've not done before, and letting that discomfort or success inform your next decisions. "You're wrong," she said plainly. "Creativity is born of limitation, not freedom." Having arrived at a circumstance of excessive limitation, the conversation that had rattled me suddenly made a lot more sense.

So, here are the simple rules I gave myself to produce *Lunch Hour*: whenever my schedule allows, make a work on paper using only the materials I have in my desk. If possible, try to complete each piece in a single sitting. If I can't, that's okay, but keep each working session down to one-hour minus the time it takes to eat a sandwich. Don't worry that it won't look like what others around me think is "art," and don't worry that there isn't a commercial gallery within a two-hour drive that would show anything like it. Just keep making. Because what does art really matter in our culture of work, anyway? We live in an era when we're lucky to have any kind of job at all, when it's understood that the proverbial carrot will always hang just out of reach, and that we have no choice but to labor in pursuit of our new holy grail: work-life balance.

Notes

Max Nisan and Vivian Giang, "The 25 Best Companies For Having A Life Outside Of Work," *Business Insider*, July 19, 2013 (http://www.businessinsider.com/the-25-best-companies-for-work-life-balance-2013-7?op=1)

Christine M. Riordan, "Work-Life Balance Isn't the Point", *Harvard Business Review*, June 4, 2013 (http://blogs.hbr.org/cs/2013/06/work-life_balance_isnt_the_poi.html).

Riordan's article proposes that we should embrace our disparate performative identities—resetting our individual expectations for what we can achieve as a worker, parent, sibling, spouse, son or daughter, friend—thus maximizing our effectiveness in each mode while diminishing the stress we feel from failing at the others, since we just can't do it all...

Ty Kiisel, "'Work-Life Balance' Should Be 'Work-Life Integration'," *Forbes*, July 16, 2013 (http://www.forbes.com/sites/tykiisel/2013/07/16/work-life-balance-maybe-we-should-recognize-its-really-work-life-integration/)

Kiisel's article proposes that we should aspire to have our holistic identities merge seamlessly with our work identities, making every waking hour "on-mission." In this impossible scenario, everyone would have a vocation, invoking the semi-holy undertones the term implies.

Rachel King, "Jive survey hints the work/life balance concept is dead," *ZDNet.com*, August 22, 2013 (http://www.zdnet.com/jive-survey-hints-the-worklife-balance-concept-is-dead-7000019750/)

King's article concedes that work-life balance, as its own unique concept, is now passé, because simply put, work won and the data shows it.

About the making of this volume: Six years after producing the original works on paper, I finally had time to work on the book version of this project. All of the elements needed to put the book together, from the digital copies of the original pieces through final design and layout, were done by me, in small bites between 5:00-6:00am over many months in 2013. Is there a more perfect example of the ongoing struggle to pursue one's own art-family-work-life balance? Oh well... I hope you enjoy it and... Onward!!!

You Can't Get There From Here

found rental car map, found bed and breakfast rack card,
glue stick, half-sheet stationary

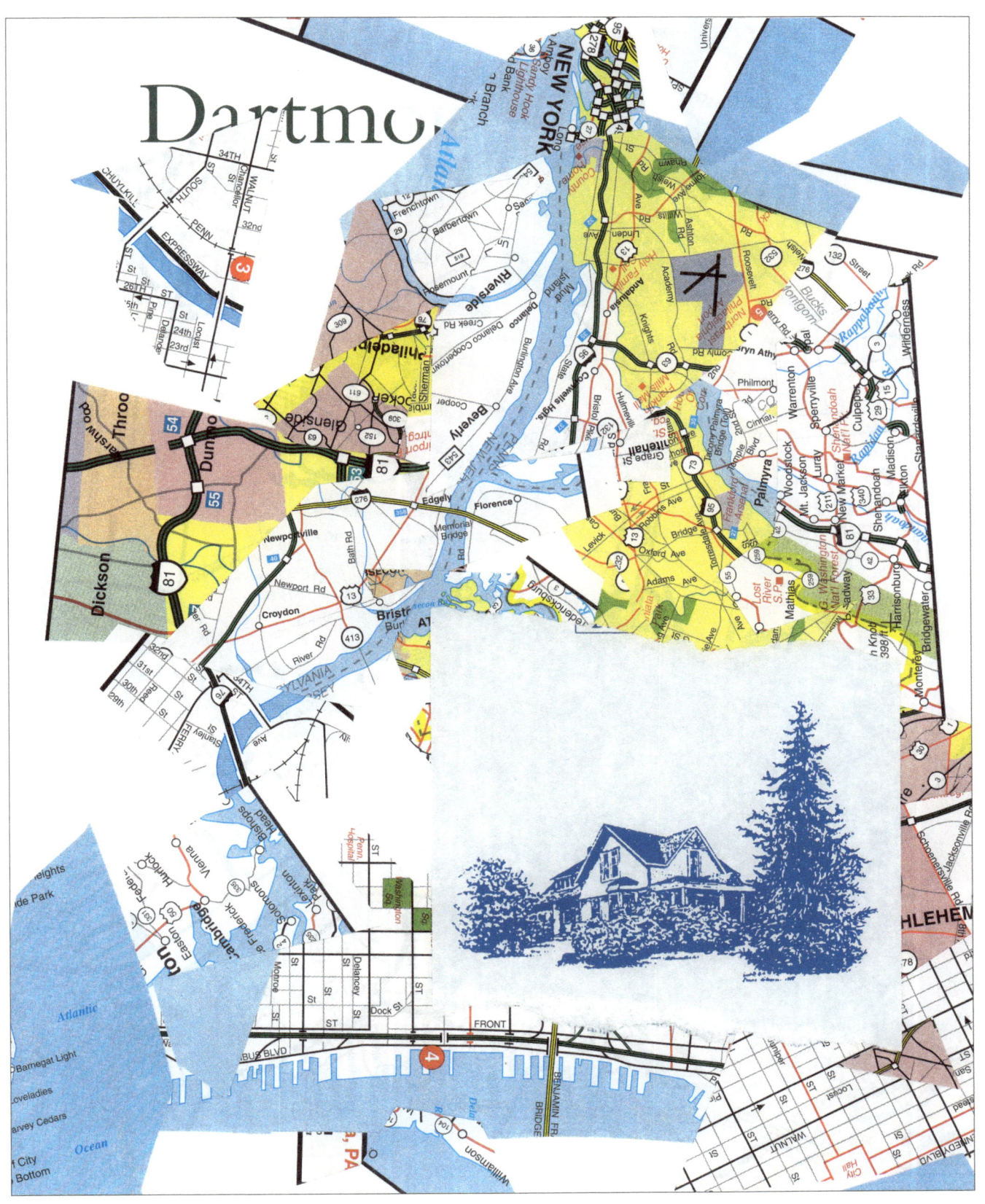

The Cornish-Windsor Covered Bridge:
The Longest Two-Span Covered Bridge in the World

3" x 5" note card, telephone message carbon papers, found postcard, legal pad, velcro tape, brown paper bag, manila envelope, post it, shredded documents, glue stick, half-sheet stationary

Dartmouth

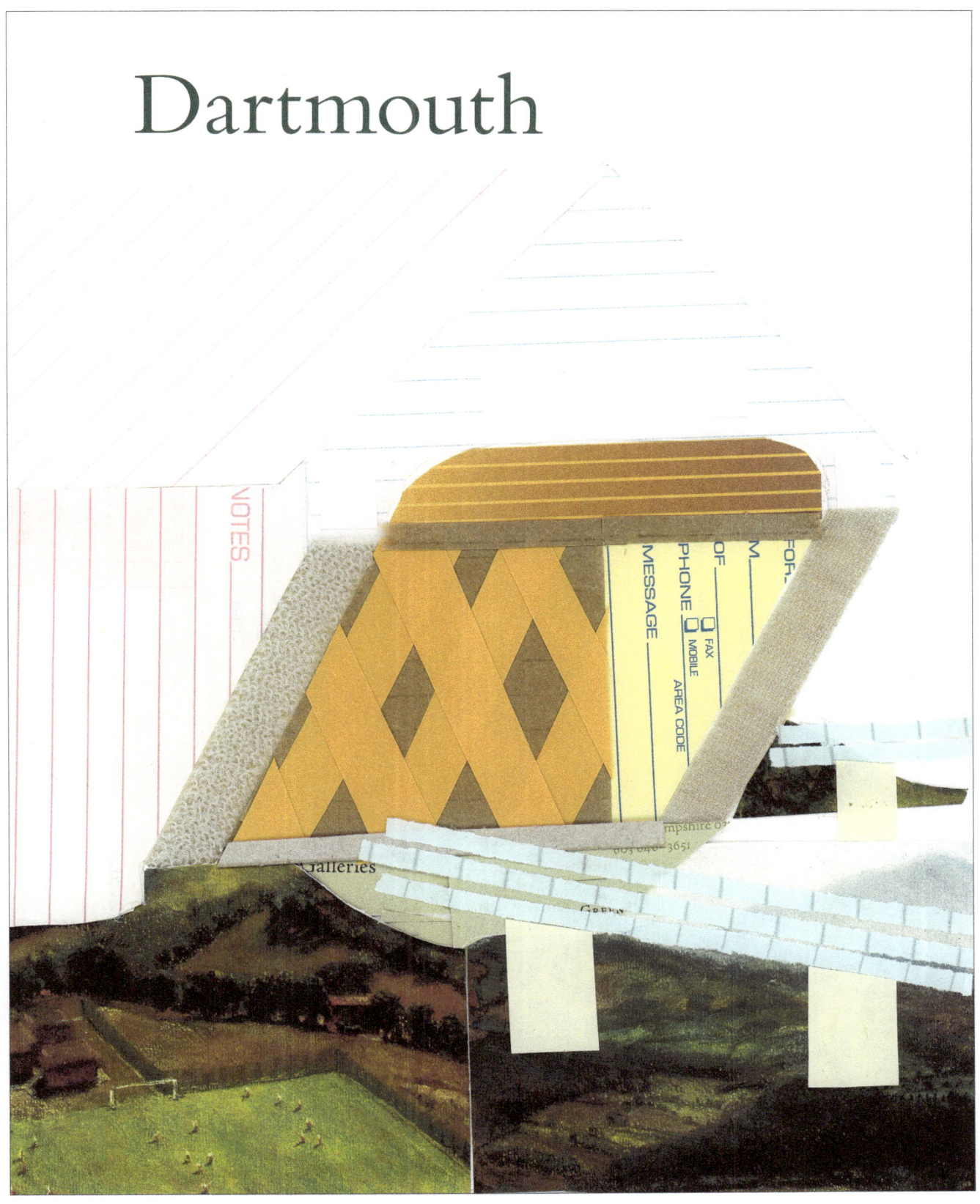

These Materials Can Be Re-Used

obsolete train schedule, post-production recycling sticker,
manila envelope, post it, plastic hole reinforcements,
colored dots, glue stick, half-sheet stationary

artmouth

	7:50 AM	
AM	8:10 AM	8:35 AM
8:20 AM	8:30 AM	8:55 AM
8:40 AM	8:50 AM	9:15 AM
9:00 AM	9:10 AM	9:35 AM
9:20 AM	9:30 AM	9:55 AM
9:40 AM	9:50 AM	10:15 AM
10:00 AM	10:10 AM	10:35 AM
10:20 AM	10:30 AM	10:55 AM
10:40 AM	10:50 AM	11:15 AM
...
5:40 PM	5:50 PM	6:15 PM
6:00 PM	6:10 PM	6:35 PM
6:20 PM	6:30 PM	6:55 PM
6:40 PM	6:50 PM	7:15 PM
7:00 PM	7:10 PM	7:35 PM
7:20 PM	7:30 PM	7:55 PM
7:40 PM	7:50 PM	8:15 PM
	8:10 PM	

	6:40 AM	6:50 AM
AM	7:10 AM	7:20 AM
7:15 AM	7:40 AM	7:50 AM
7:45 AM	8:10 AM	8:20 AM

If You've Ever Worked In A Large Institution,
Then You Get Why This Is Funny
And Also Why It's Necessary

microsoft word, laserjet ink, half-sheet stationary

Dartmouth

P	L	C	D	C	G	L	B	T	C	O	B	E	M	A	A	&	S
L	W	E	P	A	N	C	A	F	A	E	B	A	C	C	A	O	D
N	M	R	N	A	M	B	E	P	G	U	L	Y	B	U	N	T	A
N	A	A	A	G	E	U	P	N	E	D	C	F	I	F	C	A	R
R	&	D	R	P	E	A	C	G	N	C	C	A	S	A	S	S	H
T	E	P	M	L	G	E	S	O	P	E	S	A	B	D	S	R	F
D	S	G	H	P	B	W	C	I	C	R	D	O	C	Y	A	D	A
S	A	E	N	I	W	D	C	R	N	O	F	D	C	D	J	S	G
C	L	I	P	P	H	B	U	D	A	P	A	A	S	D	S	S	O
D	E	N	C	D	C	M	B	L	C	O	S	O	O	C	D	C	D
S	E	B	U	T	A	I	A	C	U	C	R	E	S	D	I	S	A
L	A	C	S	T	F	&	R	C	O	S	P	E	C	B	A	D	A
S	S	A	A	R	C	A	D	H	M	C	S	A	F	E	W	A	G
C	C	C	T	D	C	A	C	R	D	&	A	A	L	I	N	Q	U
S	Y	B	U	N	T	C	G	T	T	P	P	H	D	A	G	L	O
C	O	L	T	A	C	&	S	D	W	I	F	S	P	D	R	O	B
C	P	H	S	M	H	M	H	O	U	N	A	P	T	L	E	E	D
O	C	O	S	L	U	R	A	I	D	O	S	P	N	N	E	R	S
A	R	O	E	C	I	D	E	I	S	L	D	O	S	S	C	O	I
V	L	S	A	C	E	C	S	R	W	I	T	E	J	A	R	S	?

After you have located ALL the following
DARTMOUTH COLLEGE ACRONYMS...
the remaining letters spell out A PUZZLE FOR OUR TIMES.

THE LIST:

PLC, CGLBTC, BEMA, A&S, WEPAN, CAFA, EB, CCAOD, NMR, AMBEP, LYBUNT, NAAA, UPNE, DCF, IFC, AR, R&DR, PEAC, NCCC, SASH, TEP, LG, SOPES, ABD, RF, DSGHP, WCIC, DOC, YADA, SAEN, WDCR, OFDC, DJS, CLIPP, HB, DAPAAA, DSO, DEN, DCMB, COSO, CDCD, BUTA, IACUC, ESD, ISA, LACS, F&RC, SPEC, BADA, SSAARC, DHMC, SAFE, WAG, CCC, DCAC, D&AA, LINQ, SYBUNT, CG, TPP, DAGLO, COLT, C&S, DWI, FSP, DRO, CPHS, MHMH, NAP, LEED, COSL, RAID, OSP, NNE, ARO, CIDE, IS, DOSS, COI, LSA, CECS, RWIT, JAR.

(Bonus: How many of these <u>DARTMOUTH COLLEGE ACRONYMS</u> can you correctly identify?)

Desktop Still Life

pencil, half-sheet stationary

Dartmouth

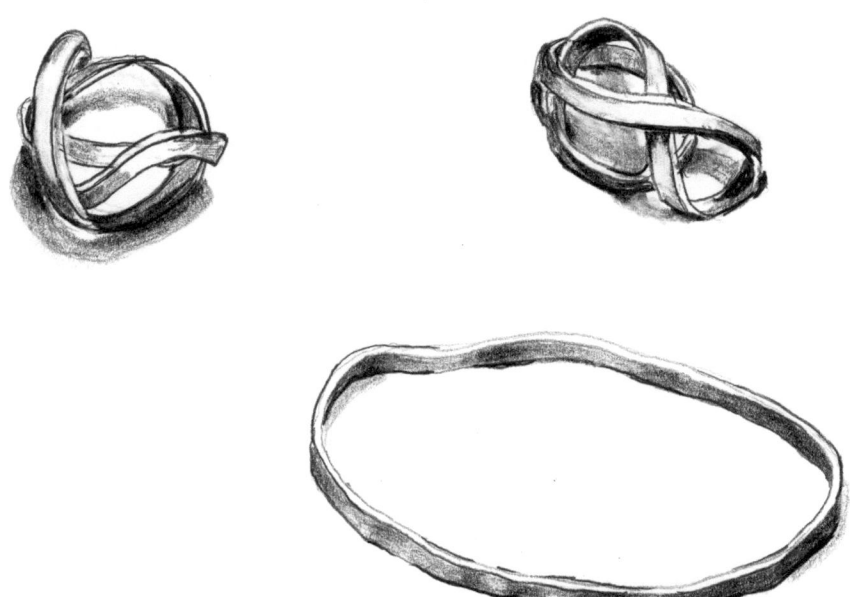

I shot the same rubber band at my computer three times. These are the ways that it landed.

Back to work...

Copy

ink, rubber stamps, half-sheet stationary

Dartmouth

208 HP4350

downloaded product image, microsoft paint, microsoft word,
avery 5160 mailing label, laserjet ink, half-sheet stationary

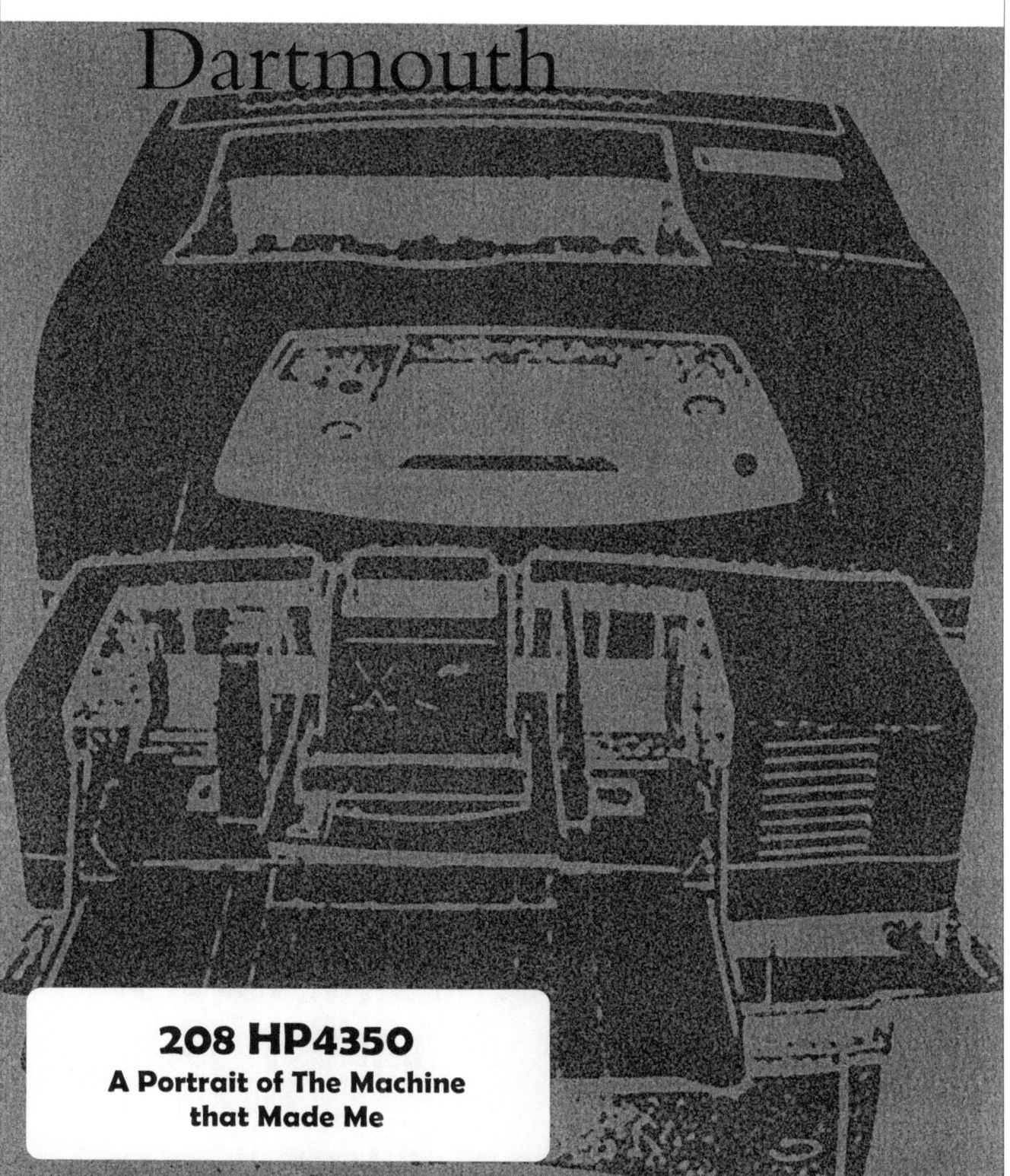

Street Style, Yo

pencil, found obsolete mailing label, half-sheet stationary

Dartmouth

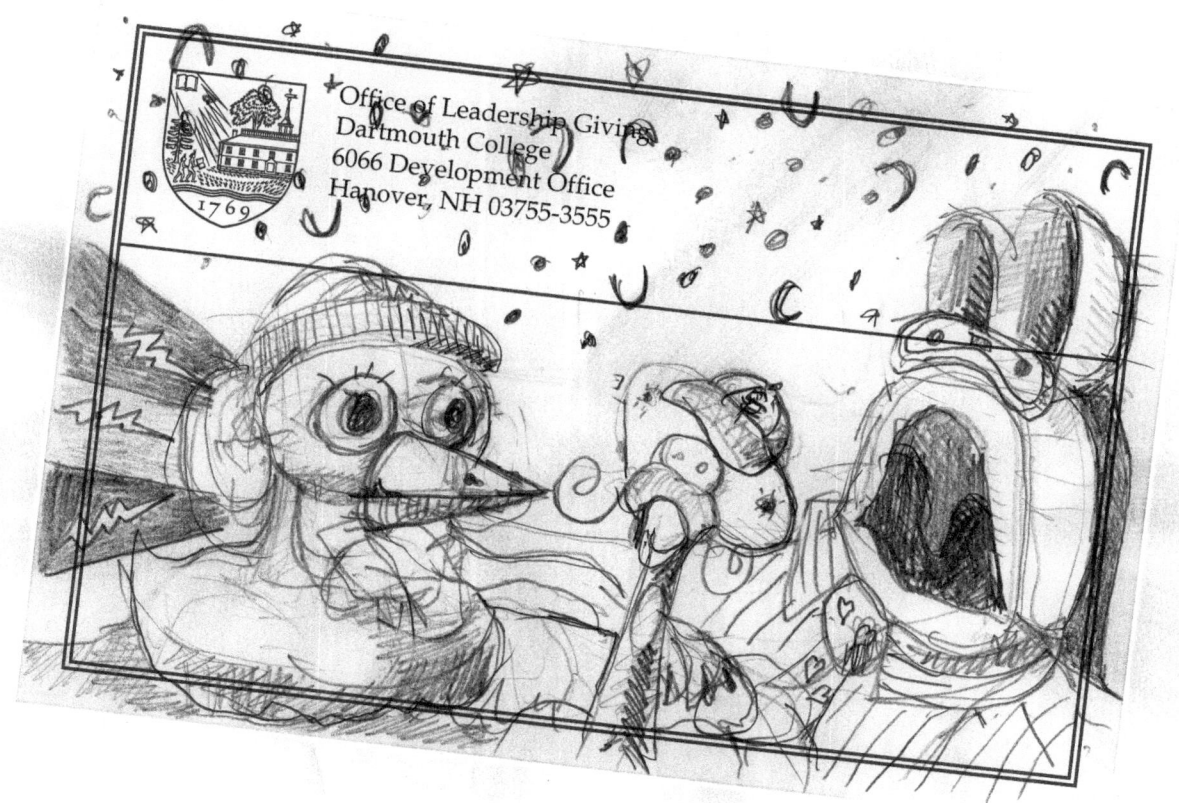

Drawing From Old Puritan Painting #1

pencil, half-sheet stationary

Dartmouth

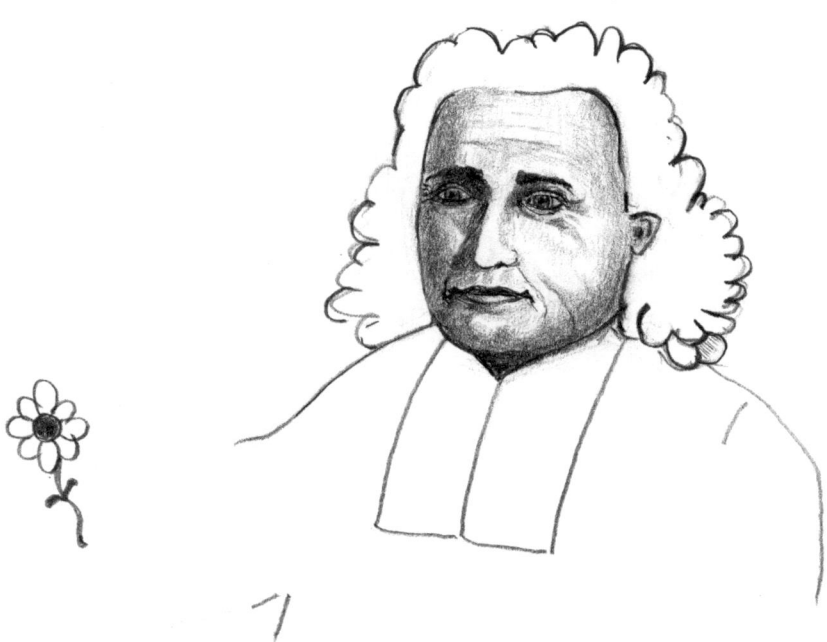

There Are Many, Many Round Things In My Desk

legal pads, file folders, manila envelope, cardboard,
white envelope, 3"x5" note card, plastic hole reinforcement,
hole punch, glue stick, half-sheet stationary

Dartmouth

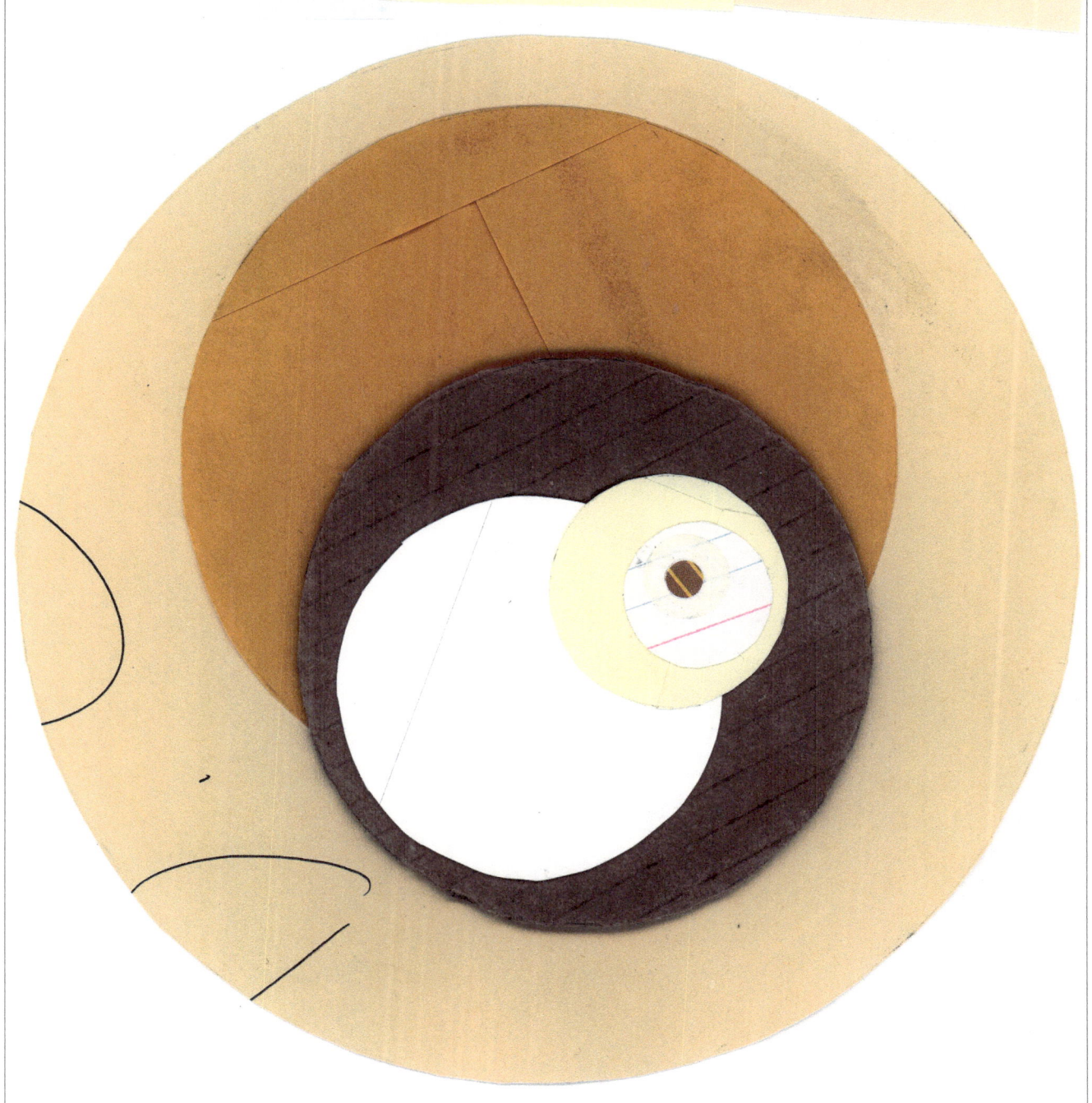

Context Is Everything

found magazine advertisement, microsoft word,
laserjet ink, glue stick, sharpie, half-sheet stationary

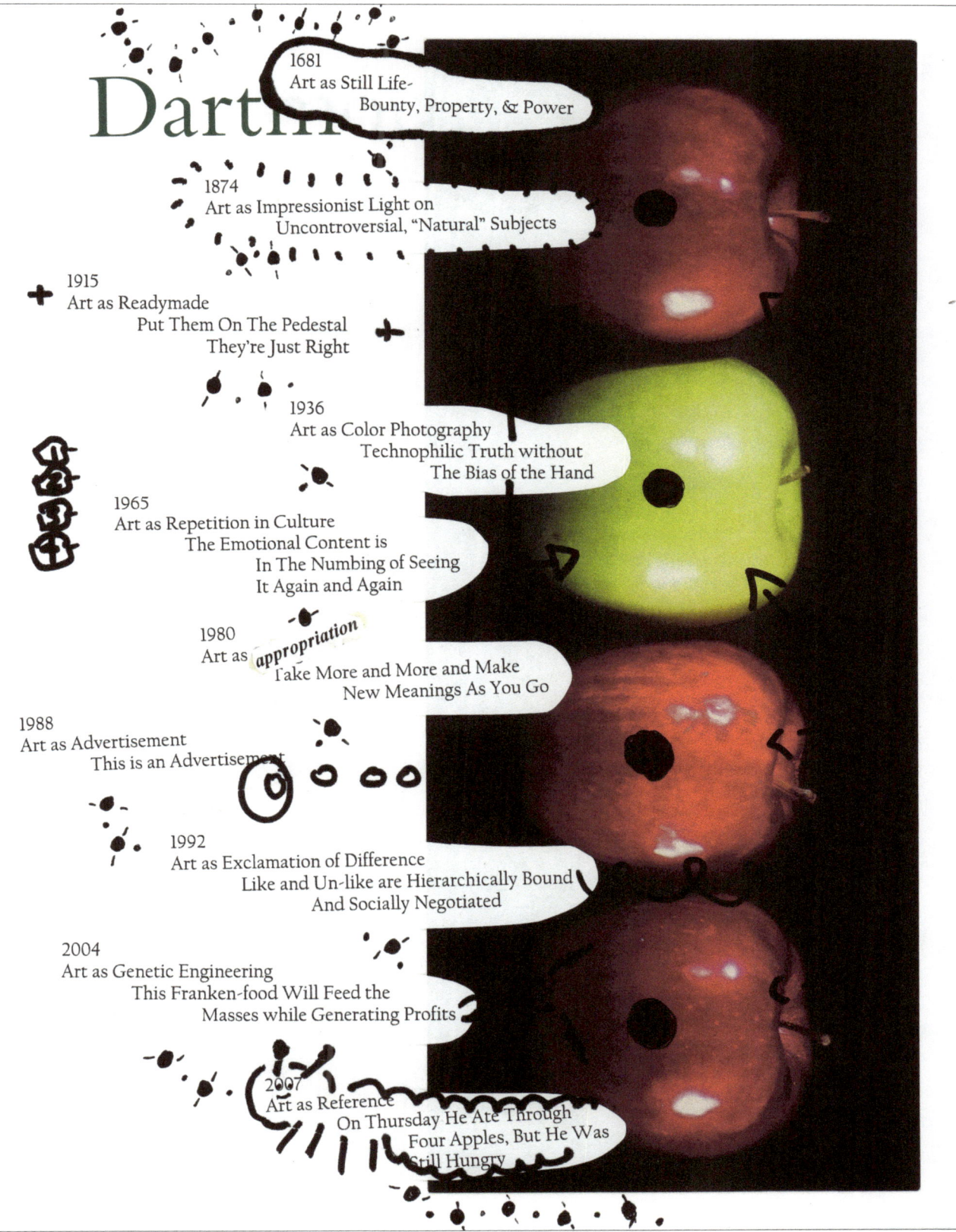

Dartm

1681
Art as Still Life—
Bounty, Property, & Power

1874
Art as Impressionist Light on
Uncontroversial, "Natural" Subjects

1915
Art as Readymade
Put Them On The Pedestal
They're Just Right

1936
Art as Color Photography
Technophilic Truth without
The Bias of the Hand

1965
Art as Repetition in Culture
The Emotional Content is
In The Numbing of Seeing
It Again and Again

1980
Art as *appropriation*
Take More and More and Make
New Meanings As You Go

1988
Art as Advertisement
This is an Advertisement

1992
Art as Exclamation of Difference
Like and Un-like are Hierarchically Bound
And Socially Negotiated

2004
Art as Genetic Engineering
This Franken-food Will Feed the
Masses while Generating Profits

2007
Art as Reference
On Thursday He Ate Through
Four Apples, But He Was
Still Hungry

Even Mr. T Loved Nancy Reagan In The '80's,
But I Never Did

found magazine cover, shredded documents, colored dots,
scotch tape, hole punches, glue stick, half-sheet stationary

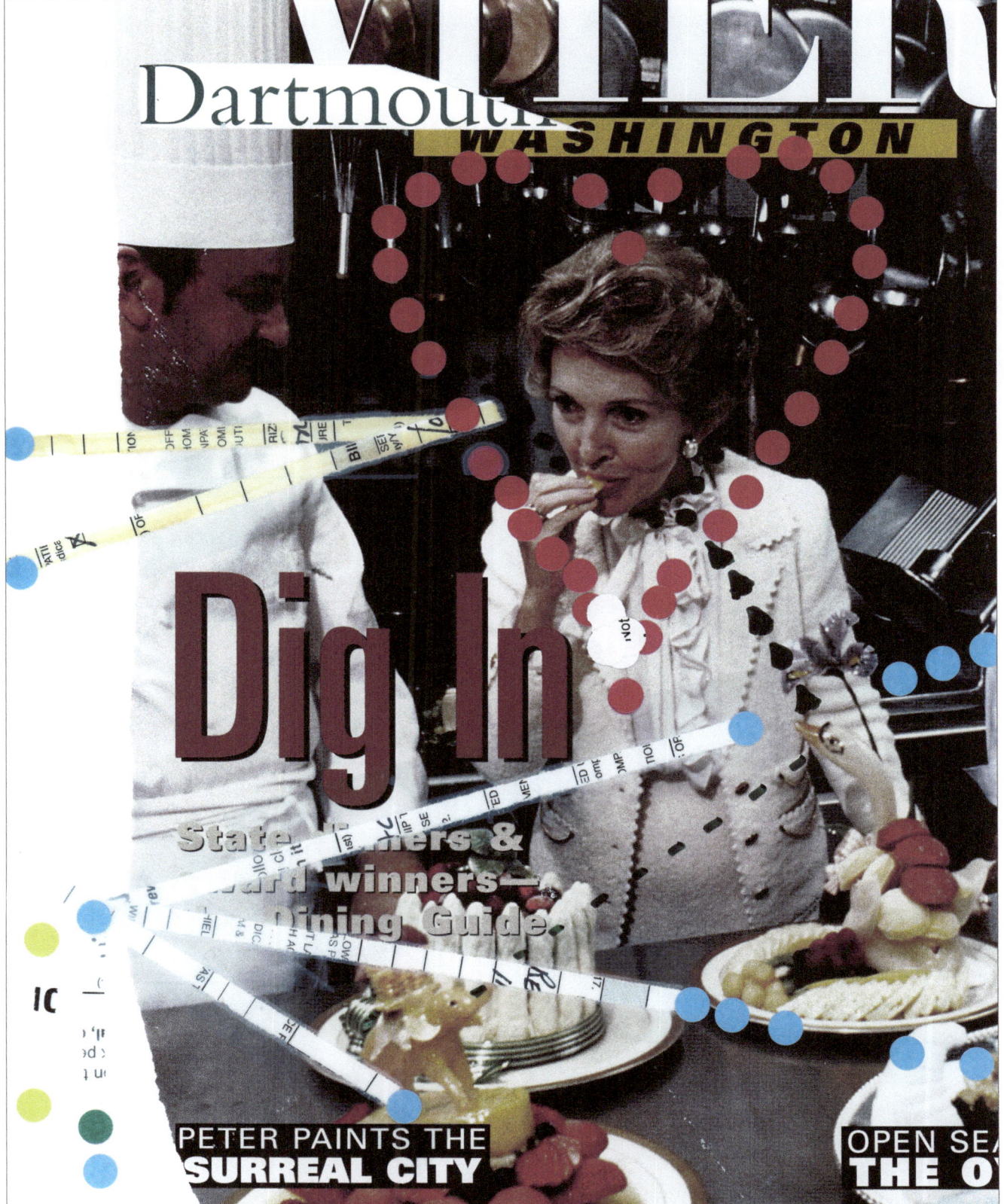

DNA

colored dots, plastic hole reinforcements,
pencil, half-sheet stationary

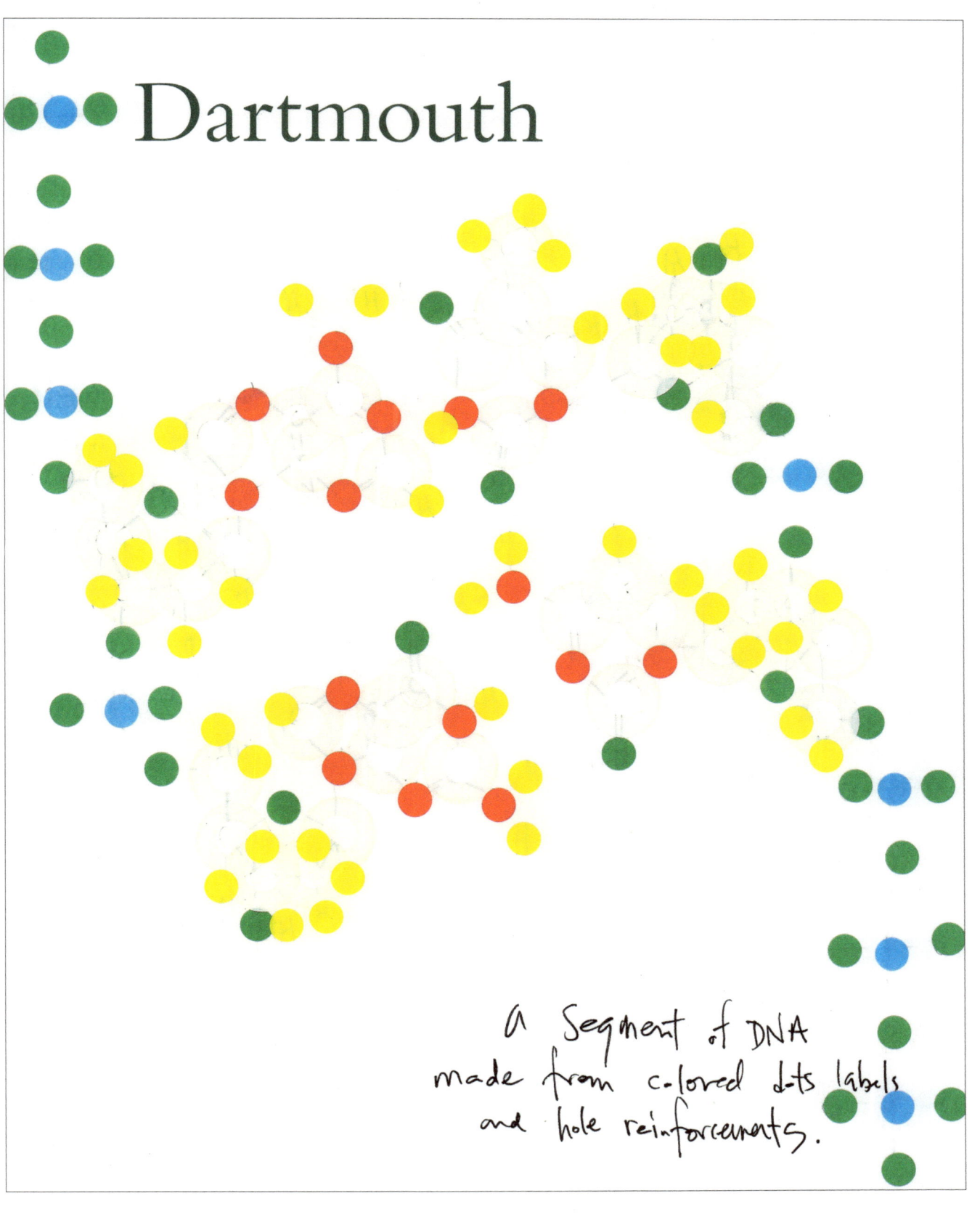

A segment of DNA made from colored dots labels and hole reinforcements.

Office-Wide Party Pass

semi-transparent colored dots, cut glacine three-ring binder
cover sheet sleeve, re-usable name card holder with elastic
lanyard, small format document tabs, half-sheet stationary

Dartmouth

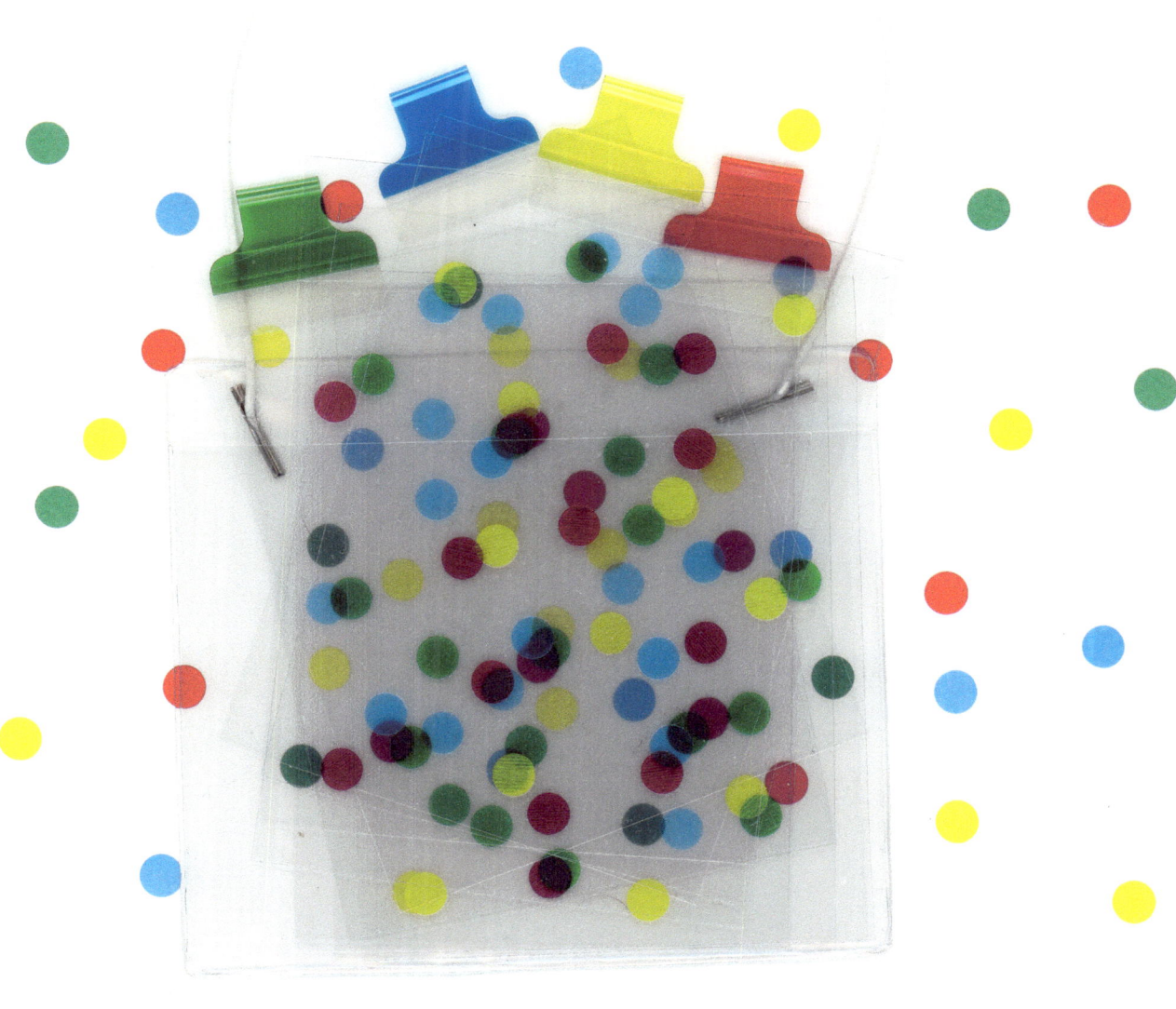

1ˢᵗ One In

pencil, half-sheet stationary

Dartmouth

1st One In...

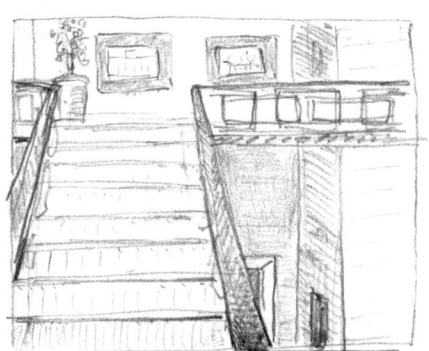

Caffeine Makes The World Go 'Round

coffee, tea, milk, sugar, avery 5160 envelope labels,
hole punches, half-sheet stationary

Dartmouth

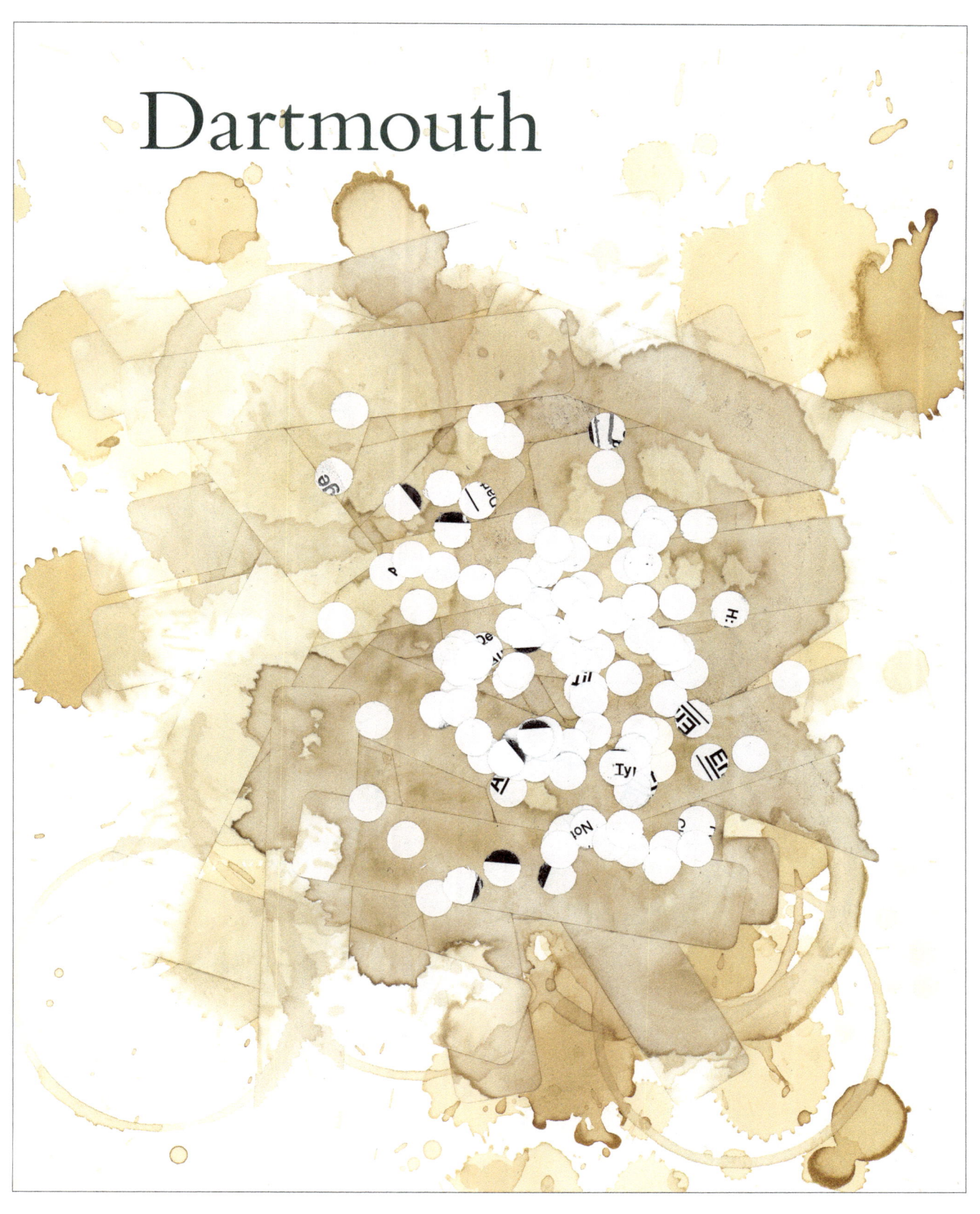

This Must Be Important

manila envelope, rubber stamp,
ink, half-sheet stationary

Dart

CONFIDENTIAL

Car Wash

pencil, ink, plastic ribbon, scotch tape,
half-sheet stationary

Dartmouth

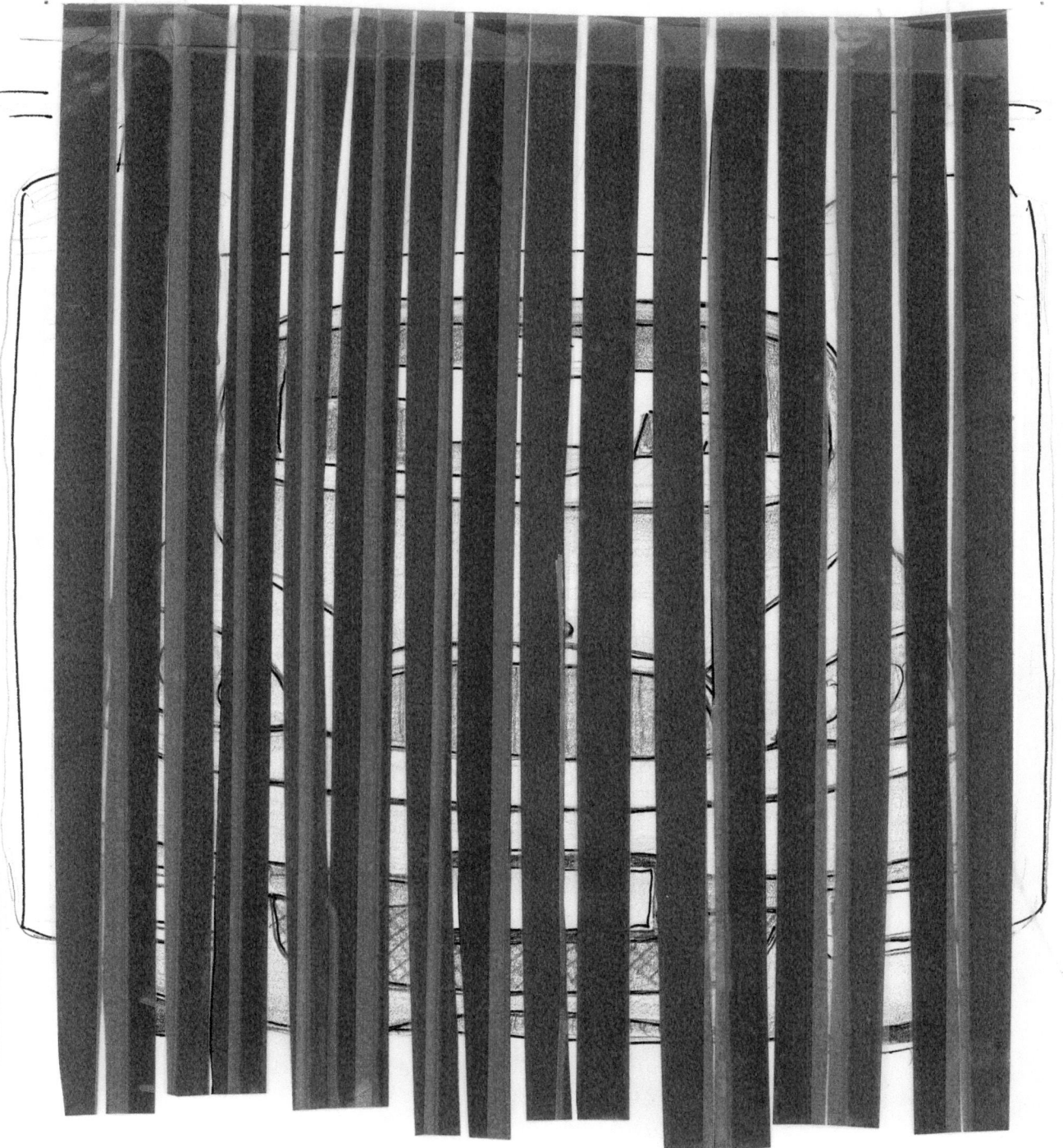

Depressing, But True

ink, sharpie, half-sheet stationary

Dartmouth

Inside each bite of food you eat is a tiny piece of shit...

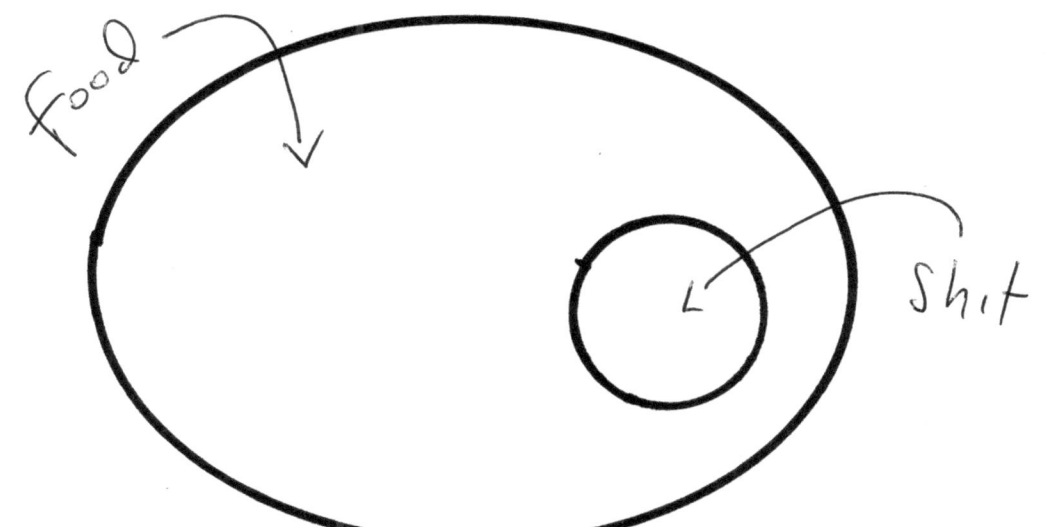

The same is true of many things — particularly Work is Art.

An Outline Of Ways For Keeping It Together

ink, half-sheet stationary

Dartmouth

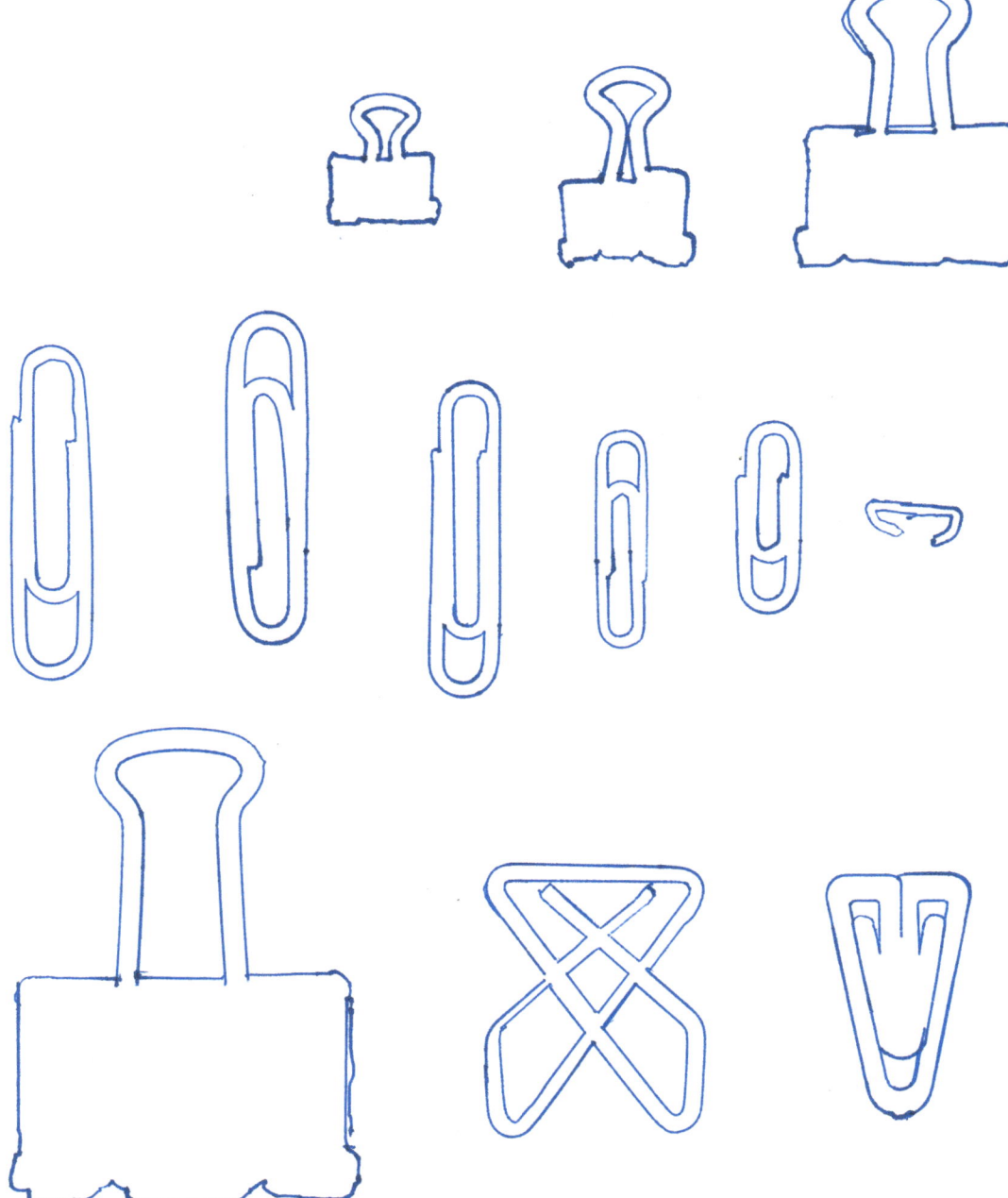

Drawing From Old Puritan Painting #2

pencil, half-sheet stationary

Dartmouth

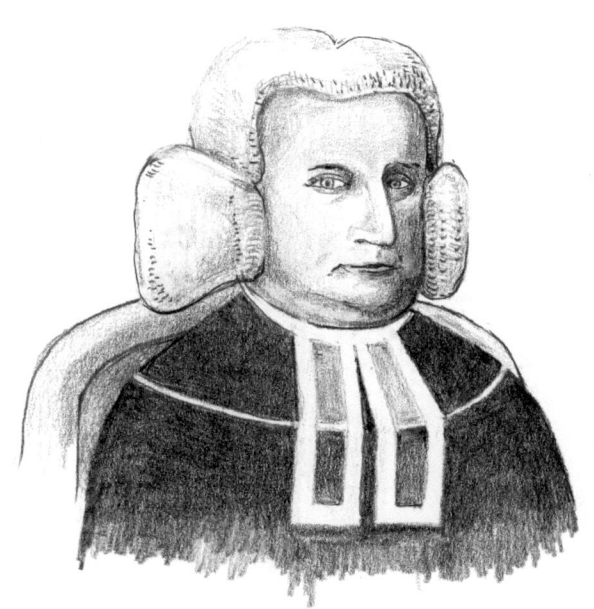

A Zipper For Philip Guston

sharpie, post it flags, half-sheet stationary

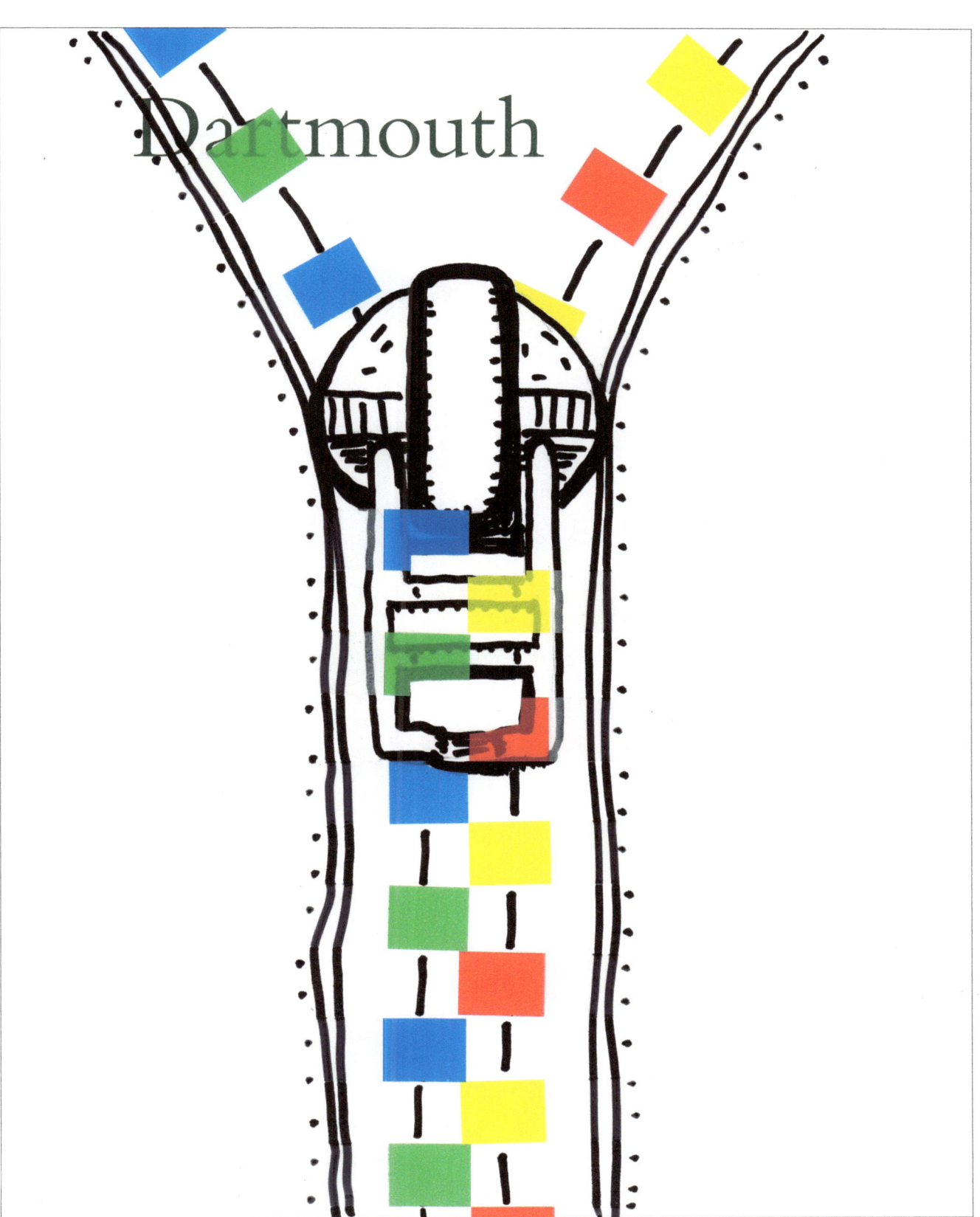

Are Process-Based Abstract Line Drawings Extra-Smart
Or Extra-Ironic When Made With Office Supplies?

pencil, highlighter, ink, half-sheet stationary

Dartmouth

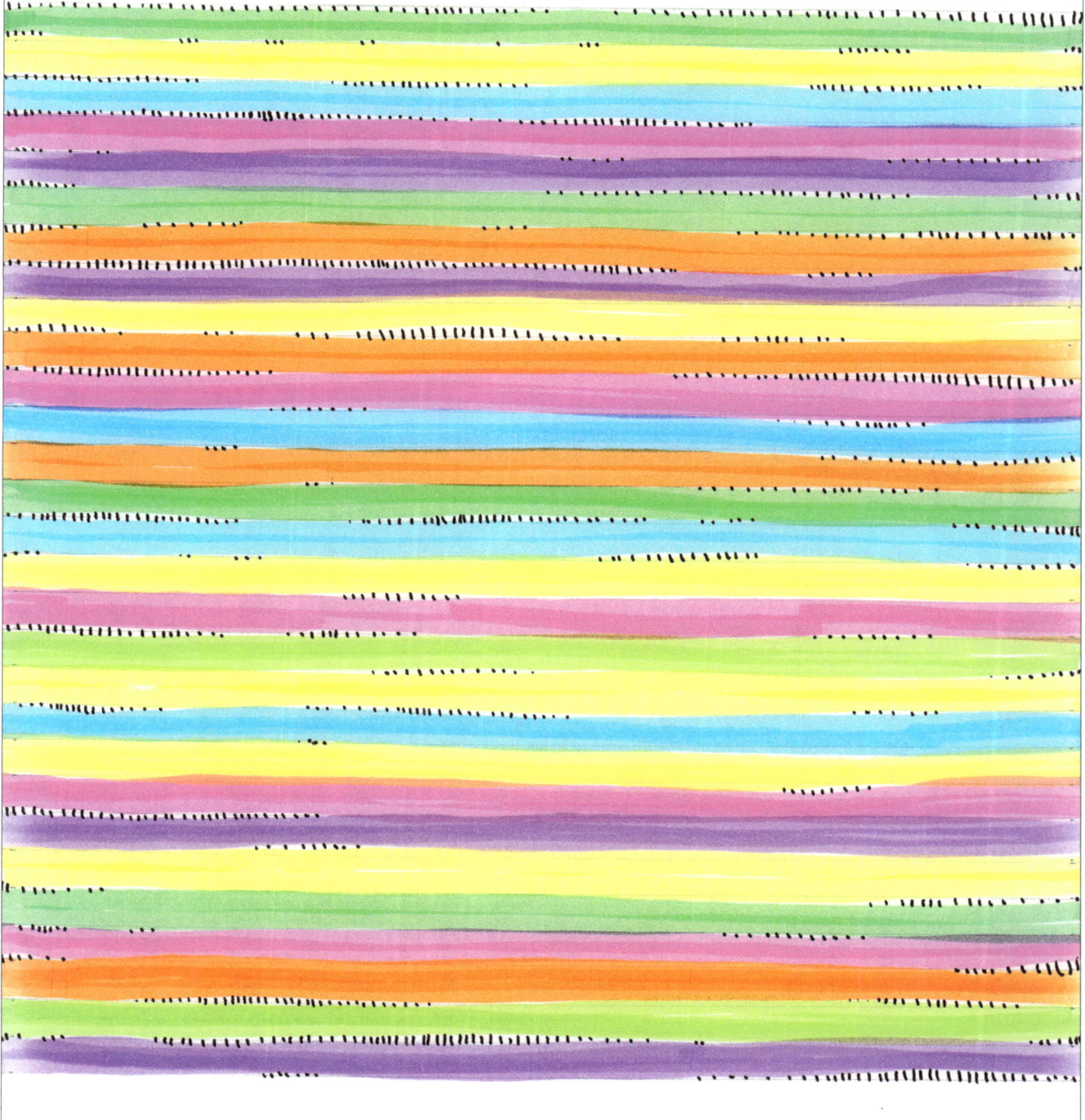

Home Again, Home Again Lickity-Split

xerox copies of found bed and breakfast marketing 3-fold,
highlighter, glue stick, half-sheet stationary

Dar

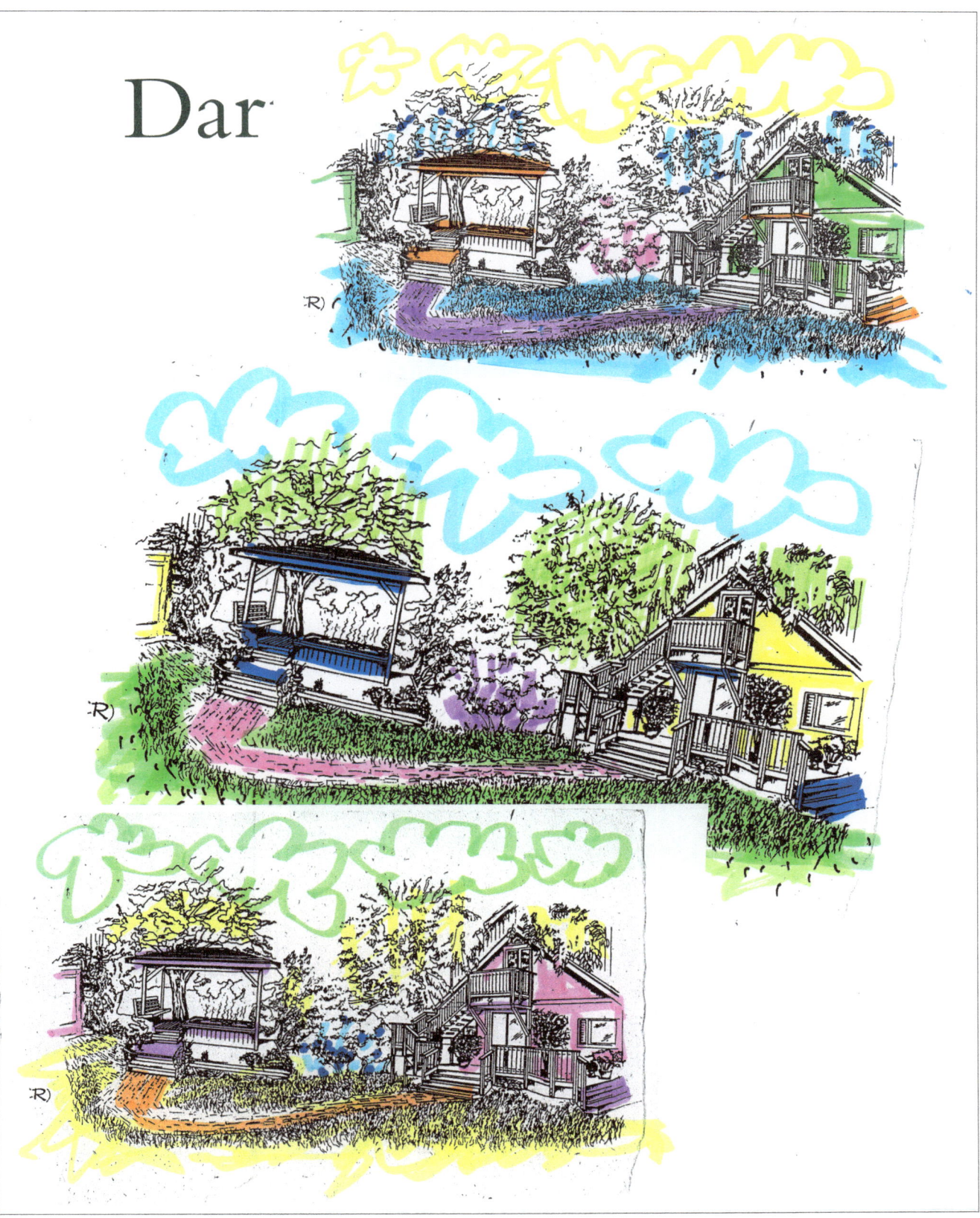

www.ingramcontent.com/pod-product-compliance
Lightning Source LLC
Chambersburg PA
CBHW050804180526
45159CB00004B/1547